ULTIMATE
TAYLOR SWIFT
Paint by Sticker BOOK

LOGAN POWELL

DESIGN ORIGINALS
an Imprint of Fox Chapel Publishing
www.d-originals.com

Introduction 4
What is Mosaic Art? 5
Taylor Swift Through the Eras 7
Photo Gallery 17

Arena Opener — page 21	*Fearless* Tour — page 23	V Festival — page 25
Movie Premier — page 27	"Long Live" — page 29	Westfield London — page 31

VMA Red Carpet — page 33	Pop Artist — page 35	*Reputation* — page 37
Happy Birthday! — page 39	Tour of the Year — page 41	Woman of the Decade — page 43
Eras Tour — page 45		

Taylor's Lucky Number 47
Stickers 48

© 2024 by New Design Originals Corporation, www.d-originals.com, an imprint of Fox Chapel Publishing, 800-457-9112, 903 Square Street, Mount Joy, PA 17552.

ISBN 978-1-4972-0693-9

All rights reserved.

Printed in China
First printing

This book is an independent and unauthorized publication. No endorsement or sponsorship by—and no affiliation with—Taylor Swift or any of the companies that offer authorized products and services relating to Taylor Swift are claimed or suggested. All references in this publication to intellectual property owned by Taylor Swift and her affiliated companies are for the purpose of identification, commentary, criticism, and discussion. Purchasers of this book are encouraged to buy the authorized products and services related to Taylor Swift.

Images used as inspiration for art from www.Alamy.com: Geoffrey Robinson, 9; Imagespace, 29; ZUMA Press Inc., 5 and www.Shutterstock.com: A.PAES, 13; Brian Friedman, 23; D Free, 25, 27; Everett Collection, 7; Featureflash Photo Agency, 15, 19; Kathy Hutchins, 21; Tinseltown, 11, 17.

Introduction

Did your love story with Taylor Swift start when you were in middle school, playing "You Belong with Me" at top volume in your headphones? Or was it when you were flipping through radio stations in the car and "Bad Blood" caught your attention? Did you discover her in her *Reputation* era, and then later found her country music? Or maybe you read a rumor about her online or saw her accept an award onstage and thought you might research the global superstar further—leading you down a rabbit hole of fascinating easter eggs and captivating stories of love and woe.

Whatever journey you took to lead you here—whether you're a tried-and-true Swiftie or a casual fan passing through—you're welcome within these pages. You're invited to read Taylor's wise quotes, relive her iconic moments, and learn new facts as you piece together artwork of the star who makes us all feel accepted, one sticker at a time. As you travel through Taylor's eras, think about which one you identify with most (are you more *Speak Now* or *Evermore*?), reminisce about her past, and even get excited for the future. Because, while Taylor Swift has a lot of accolades, albums, and awards under her belt, you can bet that she has a lot more on the way. Someone as enchanting, talented, and hardworking as Taylor doesn't just come and go. She's here to stay throughout the midnights, labyrinths, and cruel summers, all the way into the daylight. Are you ready for it?

What Is Mosaic Art?

As you're working through this book to complete Taylor Swift–inspired artwork, you'll actually be working in a modified form of art that dates back to Greek and Roman times! Your creations made with paper stickers are a form of mosaic portrait making. And just like the legendary Taylor Swift, the Greeks and the Romans often created portraits of famous musicians! Read on to find out more.

Creating mosaic sticker art is fun and simple. All you have to do is match up the colored stickers to their corresponding number on the picture page. As you peel and stick, your design will slowly come to life, just like they did for the artists in ancient history! Mosaic is the ultimate way to create something big out of many little elements. Use your imagination; the options are limitless!

Something to think about as you create sticker mosaics of Taylor Swift in this book is the history of the ancient art form. Mosaic is an artform used all throughout history, dating all the way back to 3300 BCE. Mosaics are made by placing colorful pieces of glass, tile, stone, or even seashells together with plaster to create a larger picture or pattern. Mosaic art is like the world's oldest puzzle, found everywhere from Mesopotamia to the Roman Empire, even into the modern day!

Mosaic sticker art is fun and easy. Just peel, stick, and enjoy!

Back in ancient Greece and Rome, mosaic art got so popular that it spread throughout the Roman Empire. Mosaic art was found in:

- **Homes**
- **Palaces**
- **Cathedrals**
- **Mosques**
- **Walkways**

Mosaic art depicted scenes, like a jigsaw puzzle, but it could also show beautiful patterns and shapes. Some of the scenes that were created showed:

- **Animals**
- **Religious figures**
- **Politicians**
- **Everyday life**
- **Nature**

This is one of the San Vitale mosaics of Jesus Christ in Ravenna, Italy, made around 570 CE. Mosaics were created at an angle so that flickering candlelight could reflect in the glass, making the artwork glow.

When the Renaissance came, artists chose to paint instead of using mosaic. But 300 years later, mosaic art came back! Modern artists have fun creating mosaic art with many different types of mediums—some even make mosaic art with buttons or even different shades of toast! Now you can see mosaics everywhere, including:

- Kitchens
- Gardens
- Sculptures
- Park benches
- Craft projects

Mosaic art is also very important to different cultures. Rio de Janeiro, Brazil, for example, is known for its vibrant street art, including mosaic art called *azulejos*. The colorful and bright mosaics cover buildings, streets, and plazas around the city, creating a strong sense of cultural identity! Mosaic art is important to Islamic culture as well—ancient and modern mosques and palaces are covered in tiled mosaic art featuring geometric designs and religious scenes.

So, whether you create mosaic art yourself with stickers and tiles, or you enjoy learning the history of this beautiful art form, mosaic art can teach you how to appreciate the small things—because when put together, little pieces create a stunning big picture!

This ancient mosaic, a part of the Great Palace Mosaics Museum, dates back to the Byzantine period. It is in Istanbul, and was created in the sixth century CE.

You might have seen mosaic art in your kitchen or garden, like these mosaic flower pots.

Park Güell is an example of a modern mosaic art piece. It was created by Catalan artist Antoni Gaudí, and opened as a public park in Barcelona, Spain, in 1926.

Taylor Swift Through the Eras

Taylor Alison Swift has been a singer-songwriter since she was 14 years old. For almost two decades, she has been in the public eye pouring her life into her music, wearing her heart on her sleeve, and creating a musical world for millions of people to relate to and find strength in. However, Taylor is more than just her music. *1989* is not just the name of her fifth studio album (and fourth rerecording), but it's also the year she was born in West Reading, Pennsylvania. "The Best Day" is an emotional song from her acclaimed album *Fearless*, but it also lets listeners into her childhood—the bullies, the memories, and the small moments with her mother, Andrea. And 13 is not just a lucky number that she wrote on her hand in during her *Speak Now* era; it's a number that has traveled with her from birth to present day, bringing success, acclaim, and luck wherever she goes.

Taylor Swift grew up in the spotlight. But unlike other artists, she has also grown through her music. Her past 11 eras are unique—by thinking of the album name, you can feel and experience Taylor's life at that exact moment in time; whether it's young innocence or crushing reality that she experiences. Because of this, Taylor Swift is more than a superstar, and her fans are more than admirers. There is a relationship that has been forged through the sharing of lives through music. There is a history—not just the history of her chart-topping albums, but the history of a woman who is a storyteller, a romantic, and an artist. The eras are not just albums. The eras are Taylor's life. Here is the story of Taylor Swift through these eras. Here is the story of the ultimate storyteller.

Taylor performing at Madison Square Garden, 2019.

Before the Eras (1989–2006)

Taylor Swift was born on December 13, 1989. Perhaps this is where her love of the number 13 came from—she turned 13 on Friday the 13th, after all. She was born to parents Scott and Andrea Swift. Later, her younger brother, Austin, would complete their family. Taylor grew up in Wyomissing, Pennsylvania, on a Christmas tree farm. Her grandmother, Marjorie, was an opera singer in Singapore and Puerto Rico, which may have sparked her interest in music.

Her career grew rapidly from there. When she was nine, she took vocal and acting lessons. When she was 11, she sang "The Star-Spangled Banner" at a Philadelphia 76ers basketball game. By age 12, she began to write her own songs (her first song was called "Lucky You"). By the time she was 14, the Swift family moved to Nashville, Tennessee, to support Taylor in her dreams of being a country singer. She created a demo album, named *Taylor's Songs*, which she promoted widely. Soon enough, Taylor became the youngest person ever to have a deal with Sony/ATV Music Publishing. She signed with Big Machine Records. And the rest was Swift-ory.

Did You Know?

Taylor released the song "Christmas Tree Farm" in 2019 about her childhood Christmases growing up in Pennsylvania.

Taylor Swift (Debut) (2006–2008)

Taylor Swift's self-titled debut album was released on October 24, 2006. This began what is now referred to as the Debut era. Taylor was a country singer-songwriter through and through. Country music lends well to Taylor's artistry—storytelling, honesty, and guitar playing are the main components of a great country song. And that was prevalent in Taylor's music: she captured people's attention by being unapologetically herself. She wrote about the boys in class that she had crushes on, and the personal insecurities and fears that any 14-year-old girl would have. But unlike other 14-year-old girls, Taylor was performing for people on stages and arenas when she opened for artists like Brad Paisley. Her personal diaristic confessions jumped off the page and topped the Billboard charts.

Songs like "Teardrops on My Guitar," "Tim McGraw," and "Picture to Burn" are iconic Debut era examples. Naivety, youth, and romantic hope stain the lyrics, while the catchy melodies stay in your brain long after the songs are over. The cover of this album is teal blue and green, with Taylor looking beseechingly at the camera with her curly hair, another staple of this era. She was young, eager to make a name for herself, and the definition of wearing your heart on your sleeve. In 2007, she became the youngest person to be awarded the BMI Songwriter of the Year title. After this, the awards at the CMAs, ACMs, and AMAs followed. But she was just getting started on a long journey of accolades. If only she knew how big her name would become.

Did You Know?
Taylor's artistry was inspired by Faith Hill and Shania Twain from a young age!

Fearless (2008–2010)

Fearless was Taylor Swift's second studio album, released on November 11, 2008. The *Fearless* era feels a lot like the cover of the album (and the cover of the rerecording): golden, whimsical, country-inspired, and youthful. The covers show Taylor's hair flipping in the air (which became a signature move of hers) and you can't help but feel a romantic breeze when thinking about it. The *Fearless* era represents love and hope, just like Debut, but this love and hope has an added magic to it. Taylor is a princess waiting for the prince, and the whole world is rooting for them.

Perhaps one of her best-known songs, "Love Story," was released as the lead single for *Fearless* and peaked at number four on the *Billboard* Hot 100 chart. Her second single, "You Belong With Me," is also known as a quintessential Taylor Swift song. This album also introduced some pop influences, taking the genre to country pop instead of just country. *Fearless* carried much of the innocent feelings over from Debut, with songs like "Fifteen" speaking about life as a young girl going through high school, and songs like "Fearless" putting the feeling of young love into words. This era also brought forth Taylor's first headlining tour (*The Fearless Tour*), which brought her popularity to new heights. She won more awards, including her first Grammy for Album of the Year, and she began to collaborate with other artists on movies and music. As an 18-year-old in the music industry, Taylor's star shone bright, glittering gold. The star had no choice but to continue to rise.

Taylor's famous hair flip in action.

Speak Now (2010–2012)

Along with fame and attention comes criticism that would cause anyone to doubt themselves. The *Speak Now* era was a transformative time in Taylor Swift's life. The album was released on October 25, 2010, following criticism of Taylor's voice, songwriting abilities, and love life. In the letter to her fans for *Speak Now (Taylor's Version)*, Taylor reflected on this time in her life, saying, "I had been widely and publicly slammed for my singing voice and was first encountering the infuriating question that is unfortunately still lobbed at me to this day: does she really write her songs? Spoiler alert: I really, really do." *Speak Now* was the first album that Taylor wrote completely by herself, further solidifying herself as not only a star, but an artist. She also co-produced the album, giving it every inch of herself in the creative process.

Speak Now's album cover has Taylor in a mystical purple dress with a confident look in her eye. Following the same country pop sound as *Fearless*, this album's flagship song, "Enchanted," captured the magical fairytale hope that romantics all have: One day, we'll find that special person who makes us feel enchanted, blushing all the way home. *Speak Now*'s brand of Taylor Swift—certified hope was tainted with the deep heartbreak described in "Dear John." How can a girl go through such public relationships, heartbreak, and criticism, yet still find a way to create songs that leave it all on the table? With any art, the artist is risking the dampening of their artistic spirit, but Taylor Swift's deep love for storytelling—whether it's painting the picture of a wedding crasher or the perfect first date—is truly what sets her apart from the rest. She saw the criticism and came back with even more. She spoke, and the people listened.

Taylor performing at her *Speak Now World Tour* with her iconic lucky number on her hand.

Did You Know?
The *Speak World Now Tour* grossed over $123 million dollars!

Red (2012–2014)

At age 22, Taylor was one of the world's most popular music stars, well known for her honest, wide-eyed hopes for love and relationships. Along with these hopes came raw, beautifully written songs about heartache—but it wasn't until the *Red* era that Taylor's status as a breakup songwriter really solidified. *Red* was released on October 22, 2012, and while she was slowly moving away from country music, this album pushed her further into the pop category. Even the album cover—red lipstick and a downturned face—gave a different feel for a Taylor Swift album. This album and era is less wide-eyed and more mature. Taylor seems more confident, but also has the air of someone who's been burned. *Red* is the result of a young woman putting her heart out there, getting hurt, and trying again, more cautiously.

The album debuted at number 1 in the US, selling 1.2 million copies in its first week. Perhaps one of her most personal songs, "All Too Well," however, had after-effects long after its release in 2012. For *Red*'s rerecording in November 2021, Taylor released a much-anticipated ten-minute version of the heartbreaking song, and she directed a corresponding short film. The short film and song recount a tale of lost love and public pain that not many have experienced but many can relate to. *Red* scored four Grammy nominations and VMA, AMA, and BMI awards, but what it won most importantly was Taylor Swift's place as a superstar; someone who can change, mature, and grow while still staying true to herself.

Did You Know?

Red's lead single, "We Are Never Ever Getting Back Together" became Taylor's first-ever number-one hit!

Taylor performing with her red microphone, essential to the *Red* era.

1989 (2014–2017)

While the *Speak Now* era was transformative for Taylor, the *1989* era remains her most stark transformation sonically and aesthetically. Until *1989*'s release on October 27, 2014, Taylor was seen as a country pop artist. However, in 2014, Taylor wanted a change. She was 24 years old, and although she was successful, talented, and well loved, the critics still abounded. In her acceptance speech for *Billboard*'s Woman of the Decade in 2019, she recalled, "Now [the critics] are saying my album *Red* is filled with too many breakup songs? Okay, okay, I'll make one about moving to New York and deciding that really my life is more fun with just my friends." The *1989* album cover features Taylor with a seagull shirt while Taylor's Version has her smiling at the beach. The album and era are full of synth-pop fun, but deep down, each song has the heart-stopping lyrics that Taylor has always been known for.

1989 sold 1.28 million copies in its first week, and "Bad Blood," "Shake It Off," and "Blank Space" reached number one in the US, Australia, and Canada. *The 1989 World Tour* became the highest-grossing tour of 2015, and made $250 million. She was no longer a teenage girl writing songs in her notebook and playing them in the parking lot. She was creating massive shows, selling out stadiums, and breaking records. When it was rereleased in October 2023, it sold 3.5 million units globally, making Taylor the first artist to have six number-one album debuts with over one million units sold in history. The *1989* era and album not only represent change, but also freedom. Loving with an open heart, creating art, and having fun while you can. This era would end up propelling Taylor Swift even farther into superstardom.

Taylor performing "Blank Space" at the 2014 Victoria's Secret Fashion Show.

Reputation (2017–2019)

Taylor Swift's *Reputation* era is a tale of betrayal, revenge, and new love. After a public feud resulted in the media's anger, disgust, and boredom with her, Taylor retreated from the public eye for a year, seemingly dropping off the face of the planet. After being closely watched nonstop since she was 14 years old, a mid-twenties Taylor decided to seclude herself, bowing out of media appearances and interviews. She deleted all content from her social media accounts, which gained the public's attention. When she dropped her lead single, "Look What You Made Me Do," the music video broke the record for the most views in the first 24 hours of release. When *Reputation* was released on November 10, 2017, it spent four weeks in the *Billboard* 200 and was certified triple platinum. It might be one of the best comebacks in music history.

Reputation's album cover is black and white, with Taylor staring at the camera, newsprint covering half of her face. Subsequently, the *Reputation* era is identified by the color black and images of snakes—when Taylor was called a snake by the public, she used the opportunity to reclaim the reptile for her own artistic purposes. But, although the images and themes in *Reputation* are indeed those of revenge and betrayal, there are certain songs like "Delicate" and "New Year's Day" that show a softer side: new love found in Taylor's year of reflection. Taylor's music may change from country to synth pop to electropop, but one thing about her songwriting and storytelling is that she will always hope. There will always be a point in the song where you believe that maybe it could get better. *Reputation*'s stadium tour grossed $266.1 million, and the album was nominated at the Grammy's, won four AMAs, and caused Taylor to become the most-awarded female musician in AMA history. Taylor's reputation was reclaimed; and she was ready to take on the world.

> **Did You Know?**
> The *Reputation* costume in *The Eras Tour* is an iconic body suit with a red snake twisting up her entire body!

Taylor performing during *The Reputation Tour*.

Taylor posing on the red carpet for the 2019 iHeartRadio Music Awards.

Lover (2019–2020)

In 2018, Taylor switched to Universal Music Group and signed a contract where she would be able to own her master recordings. This means that her seventh studio album, *Lover*, would be the first studio album that she owned. *Lover* was released on August 23, 2019, and became the world's best-selling studio album of the year, selling 3.2 million copies. The *Lover* era, coming after the harsh black and white of *Reputation*, showed a much softer side of Taylor. The new love that was blossoming in the previous era was in full force in this one. The album cover has Taylor in a cloudy pink haze with a bejeweled heart around her eye. The color scheme of this era is pink, pastels, and light blue. Glitter, butterflies, and unicorns abound in music videos for "ME!" and "You Need to Calm Down," two hit singles from the album. A song from the album, "Cruel Summer," while not released as a single in 2019, was released in 2023 and topped the *Billboard* 100—four years later.

While the *Lover* era was bright, sentimental, and fun, with it came a public dispute with Taylor's former manager and label Big Machine Records about the sale of the masters of her back catalog (her previous six albums). Even though Taylor had been trying to purchase her masters for years, she revealed that her masters, videos, and artworks were sold for $300 million to Shamrock Holdings. The only thing left for Taylor to do was to begin the process of rerecording her first six albums so that she could one day own all her music. This was unexpected; few artists have done this before. But in 2020, amid a global pandemic, Taylor Swift began to rerecord her back catalog—and consequently make history. Again.

Folklore and *Evermore* (2020–2022)

COVID-19 took the world by surprise in 2019. Amid the lockdowns, Taylor's *Lover* era was cut short. She quarantined in London, but just because the world stopped, doesn't necessarily mean that her creativity did too. On July 23, 2020, Taylor Swift surprised the world when she announced that she would be releasing *Folklore* at midnight. While in isolation, she had collaborated with Jack Antonoff, Aaron Dessner, and Bon Iver to create a sound unlike any of her previous music. The result was an indie-folk collection of stories with made-up characters, love triangles, and sad tales of woe. *Folklore*'s album cover was also unlike any of Taylor's previous covers—it features a wide gray-and-white shot of Taylor in the woods in a long coat, looking up at the trees. This cover perfectly fits the aesthetic of *Folklore*: escapism, empathy, nostalgia, and romanticism. By using fictional characters and story arcs instead of her usual autobiographical songwriting techniques, Taylor welcomed her fans into a new world, and they responded very well.

The album debuted at number one on the *Billboard* 200 and became 2020's longest-running number one album. "Cardigan," the lead single off *Folklore*, also debuted at number one, topping Spotify charts with over 7.7 million streams. *Folklore* received five 2020 Grammy nominations, and won Album of the Year. It was one of the best surprises that Taylor Swift pulled off . . .

. . . Until December 10, 2020, just five months after *Folklore*'s release. Taylor once again surprised her fans with the news that her ninth studio album, *Evermore*, would be released at midnight. *Evermore* was introduced as the sister album to *Folklore*, and followed in its indie-folk footsteps. The cover shows the back of Taylor's head as she faces the forest. Her hair is braided, and her now-iconic plaid coat gives the feeling of autumn. *Evermore* is indeed the sister album to *Folklore*, but it may best be described as the sadder older sister. It is a collection of tales about love, marriage, infidelity, grief, and the complexity of human emotion. On Instagram, Taylor explained her inspiration: "To put it plainly, we just couldn't stop writing songs. To try and put it more poetically, it feels like we were standing on the edge of the folklorian woods and had a choice: to turn and go back or to travel further into the forest of this music."

Did You Know?
Taylor named her Los Angeles home studio the Kitty Committee Studio in the album credits for *Folklore* and *Evermore*!

While Taylor's previous albums have been categorized into siloed eras while she planned the next one after the previous album has released, Taylor felt drawn into the escapism of the world that she had created with *Folklore*, and so she let that creativity bleed into *Evermore*. The fans, it's safe to say, were not disappointed in this. *Evermore*'s lead single, "Willow," debuted at the top of the *Billboard* Hot 100 and *Billboard* 200 charts. Because of this, Taylor became the first artist to simultaneously have an album and a single at the top of both the *Billboard* 200 and Hot 100 charts on two occasions, following *Folklore* and "Cardigan." She also became the first woman to have two albums simultaneously in the top three of the *Billboard* 200.

Folklore and *Evermore* successfully shifted Taylor's status from a mainstream popstar to a recognized and acclaimed songwriter and musician. While the world was reeling from a global pandemic, Taylor Swift was hard at work creating new ways for her fans to find solace in music in ways that she had never ventured before. Creating new albums while rerecording old ones, Taylor's songwriting and storytelling reached new heights in the face of worldwide uncertainty. And she had no intentions of stopping.

Taylor performing a medley of songs from *Folklore* and *Evermore* at the 2021 Grammy Awards.

Midnights (2022–2024)

From *Folklore* and *Evermore*'s release onward, Taylor Swift worked tirelessly at rerecording her masters and releasing the albums to the fans with new vault tracks. Each album rerecording brought surges of sales and excitement as Swifties around the world reveled in the nostalgia of reliving Taylor's famous albums—and new fans discovered her country roots for the first time. So, it came as (another) surprise that, when accepting the award for Video of the Year at the 2022 MTV VMAs for her short film *All Too Well (Taylor's Version)*, she announced that she would be releasing her tenth studio album, *Midnights*, on October 21, 2022. The album cover shows Taylor in dark eye makeup looking at a lit lighter. The corresponding album artwork shows her inside a seventies-style house looking nostalgic and shimmery in her glam. In music videos for the album, like the ones for "Anti-Hero" and "Lavender Haze," she is in the same house, wearing faux fur, knits, and other retro accessories.

Midnights, playing into the nostalgia theme, is a concept album about 13 sleepless nights in her life. Each of the synth-pop tracks took listeners to a midnight in Taylor's past, exploring the themes of self-hatred, revenge, falling in love, and falling apart. "Anti-Hero," one of Taylor's most self-critical songs, was the lead single from *Midnights*, debuting at the top of the *Billboard* 200. Tracks from *Midnights* occupied the entire top 10 of the *Billboard* Hot 100 chart, earning Taylor the honor of being the first artist to simultaneously occupy the top 10 spots. *Midnights* remains one of Taylor's most vulnerable albums, with the lyrics from "Bigger Than the Whole Sky," "You're On Your Own Kid," and "Mastermind" bringing fans closer than ever before. And, with Taylor gaining more and more autonomy in the music industry, she was at the top of her game, 18 years into her career, breaking her own records and setting new standards.

The Future (2024–Present Day)

Taylor Swift seems to be getting more and more powerful, talented, and popular as the years go by. Along with the acclaim, as we've learned through Taylor's career, comes a lack of privacy, criticism, speculation, and mistruths. However, we've also seen that none of this stops the honesty that started from 14-year-old Taylor's diaristic confessions, and follows her to this very day. Whether new fan or die-hard Swiftie, Taylor's listeners have come to know her as an artist full of surprises, whether it's the genre of her next album or the easter eggs that she hides in a music video. Rerecording her old albums, directing music videos, collaborating with artists, and leaving messages for fans ensures that Taylor Swift is more than a country singer, a pop star, or even a superstar. She is an artist.

Another surprise that she gave her listeners came at the 2024 Grammy Awards as she accepted the award for Album of the Year for *Midnights*. Since it was her 13th Grammy Award, and we know that 13 is her lucky number, she announced that her eleventh studio album, *The Tortured Poets Department*, would be releasing on April 19, 2024. The album cover shows a gray-and-white shot of Taylor on a bed, body language pained and sad. Following a public breakup of a long-term relationship, Taylor spoke to the crowd during *The Eras Tour*, saying, "I needed to make [*The Tortured Poets Department*]. It was really a lifeline for me. It sort of reminded me of why songwriting is something that actually gets me through life. And I've never had an album where I've needed songwriting more than I needed it on *Tortured Poets*." In a music industry full of trends, numbers, and relevancy, Taylor Swift is unique in the fact that she has changed consistently through her career, but she has never strayed far from herself. Listening to each album, you will hear vastly different songs, but each song is at its core a Taylor Swift song. There's hope, romance, pain, dreams, revenge, and betrayal. There's stunning lyricism and beautiful melodies. There are worlds that she created, but also worlds close to home. In each album, each song, each lyric, there is Taylor Swift.

> **Did You Know?**
> "Anti-Hero" had the biggest opening day for a song in Spotify's history, getting 17.4 million streams in its first 24 hours!

Taylor promoting her debut album in 2007. If you want to create this picture as mosaic sticker art, **see page 21**.

Taylor performing during her *Fearless* tour. If you want to create this picture as mosaic sticker art, **see page 23**.

Taylor onstage in 2009. If you want to create this picture as mosaic sticker art, **see page 25**.

Taylor at a movie premier. If you want to create this picture as mosaic sticker art, **see page 27**.

Taylor performing in Rio de Janeiro, Brazil in 2012. If you want to create this picture as mosaic sticker art, **see page 29**.

Taylor performing with her iconic red microphone. If you want to create this picture as mosaic sticker art, **see page 31**.

Taylor at an event in London. If you want to create this picture as mosaic sticker art, **see page 33**.

Taylor at the 2012 MTV VMAs. If you want to create this picture as mosaic sticker art, **see page 35**.

Taylor at the 2018 *Billboard* Music awards. If you want to create this picture as mosaic sticker art, **see page 37**.

Taylor performing at the 2019 iHeartRadio Jingle Ball. If you want to create this picture as mosaic sticker art, **see page 39**.

Taylor walking the red carpet in 2019. If you want to create this picture as mosaic sticker art, **see page 41**.

Taylor posing before accepting an award. If you want to create this picture as mosaic sticker art, **see page 43**.

Taylor performing at her record-breaking *Eras* tour in 2023. If you want to create this picture as mosaic sticker art, **see page 45**.

V Festival

V Festival

Taylor performed at V Festival in England in 2009. She enchanted the crowd by performing her top hits, "You Belong with Me," "Forever and Always," and "Love Story," all while wearing her heart on her sleeve.

Swiftie Snapshot

YEARS
2008–2010

ALBUM SPOTLIGHT
Fearless

GENRE
Country pop

HIT SONGS
"Forever and Always"
"Fifteen"

AWARDS
American Music Awards:
Favorite Country Female Artist
(2010)

"When I play a song, I want people to feel like they're experiencing exactly what I went through when I wrote the song as I'm singing it to them."

—Taylor Swift

Movie Premier

Movie Premier

Taylor appeared at the 2010 movie premiere of *Easy A*, starring one of her closest friends, Emma Stone. Taylor wrote a song called "When Emma Falls in Love" presumably about the actress—but the song didn't see the light of day until *Speak Now*'s 2023 re-recording; it was included as a vault track.

Swiftie Snapshot

YEARS
2010–2012

ALBUM SPOTLIGHT
Speak Now

GENRE
Country pop

HIT SONGS
"Speak Now"
"Mean"
"Enchanted"

AWARDS
Grammy Awards: Best Country Solo Performance and Best Country Song for "Mean" (2012)

FUN FACT

Taylor wrote *Speak Now* entirely by herself between the ages of 18 and 20. She says that the songs she wrote were "marked by their brutal honesty, unfiltered diaristic confessions, and wild wistfulness."

"Long Live"

"Long Live"

Taylor performed an emotional version of "Long Live" in Rio de Janeiro, Brazil, alongside Paula Fernandes in 2012. The two came out with a remix of "Long Live" that features Fernandes singing some of the verses in Portuguese.

Swiftie Snapshot

YEARS
2010–2012

ALBUM SPOTLIGHT
Speak Now

GENRE
Country pop

HIT SONGS
"Mine"
"Back to December"
"Ours"

AWARDS
American Music Awards:
Artist of the Year (2011)
Billboard Women in Music:
Woman of the Year (2011–2012)

FUN FACT

Speak Now was originally supposed to be called *Enchanted*, but Taylor renamed it to better capture her hopes and the growth of her career at that point.

Westfield London

Westfield London

Taylor performed and turned on the Christmas lights at Westfield Shepherd's Bush, London in 2012. She promoted songs from her album *Red*. Songs included "We Are Never Ever Getting Back Together" and "Red"—instant crowd-pleasers.

Swiftie Snapshot

YEARS
2012–2014

ALBUM SPOTLIGHT
Red

GENRE
Pop

HIT SONGS
"We Are Never Ever Getting Back Together"
"22"

AWARDS
Grammy Awards: Best Song Written for Visual Media for "Safe & Sound" (featuring the Civil Wars) (2013)

FUN FACT

Taylor grew up on a Christmas tree farm in Wyomissing, Pennsylvania. She wrote the song "Christmas Tree Farm" about her whimsical memories from that time in her life and her love of Christmas.

VMA Red Carpet

33

VMA Red Carpet

Taylor walked the red carpet at the 2012 MTV Video Music Awards. She later performed "We Are Never Ever Getting Back Together" at the ceremony. Dancers, confetti, flowers, and bright lights accompanied Taylor's performance as the crowd danced and sang along to Taylor's number-one pop hit.

Swiftie Snapshot

YEARS
2012–2014

ALBUM SPOTLIGHT
Red

GENRE
Pop

HIT SONGS
"I Knew You Were Trouble"
"Red"

AWARDS
MTV Video Music Awards: Best Female Video for "I Knew You Were Trouble" (2013)

"Fans are my favorite thing in the world. I've never been the type of artist who has that line drawn between their friends and their fans. The line's always been really blurred for me."

—Taylor Swift

Pop Artist

Pop Artist

For Taylor's fifth studio album, *1989*, she wanted to enter a new era for her music, but also for her life. Previously known as being a country artist and the "girl next door," Taylor entered this stage of her life as a pop artist who had fun in New York City with her friends.

Swiftie Snapshot

YEARS
2014–2017

ALBUM SPOTLIGHT
1989

GENRE
Synth-pop

HIT SONGS
"Blank Space"
"Shake It Off"
"Bad Blood"

AWARDS
Billboard Women in Music: Woman of the Year (2014)
Grammy Awards: Album of the Year and Best Pop Vocal Album for *1989* (2016)
Grammy Awards: Best Music Video for "Bad Blood" (featuring Kendrick Lamar) (2016)

FUN FACT

The atmospheric ballad "Wildest Dreams" on Taylor's *1989* literally has her heartbeat in it. In the production credits for the song, it says: "Heartbeat—Taylor Swift."

Tour of the Year

Tour of the Year

Taylor walked the red carpet at the 2019 iHeartRadio Music Awards—she won Tour of the Year for the *Reputation Stadium Tour.* She also won Best Music Video for "Delicate," a video where she finds true happiness within herself, without worrying about what anyone thinks.

Swiftie Snapshot

YEARS
2019–2020

ALBUM SPOTLIGHT
Folklore

GENRE
Indie folk

HIT SONGS
"Cardigan"
"Betty"
"August"

AWARDS
Apple Music Awards: Songwriter of the Year (2020)
Grammy Awards: Album of the Year for *Folklore* (2021)
iHeartRadio Music Awards: Best Pop Album for *Folklore* (2021)

FUN FACT

Taylor created *Folklore* during the COVID-19 lockdowns, just a year after winning at the 2019 iHeartRadio Music Awards! She recorded most of the album at her home studio, and even created a love triangle with the characters featured in the album.

Woman of the Decade

Woman of the Decade

In 2019, Taylor accepted the first *Billboard* Woman of the Decade Award ever given. Her iconic acceptance speech detailed her experience in the music industry over the past twenty years. She spoke of women in music, saying, "It seems like the pressure that could have crushed us made us into diamonds instead."

Swiftie Snapshot

YEARS
2019–2020

ALBUM SPOTLIGHT
Evermore

GENRE
Indie folk

HIT SONGS
"Willow"
"No Body, No Crime"
"Champagne Problems"

AWARDS
Billboard Women in Music: Woman of the Decade (2019)
Guinness World Records: Shortest Gap Between New No. 1 Albums on the US *Billboard* 200 (Female) (2020)
American Music Awards: Favorite Pop/Rock Album for *Evermore* (2021)

FUN FACT

Part of Taylor's award-winning decade was writing, producing, and releasing *Folklore* and *Evermore*, two surprise sister albums in 2020. These albums have a much more folksy vibe than her previous albums.

Eras Tour

Eras Tour

Taylor performed on stage for her record-breaking *Eras* tour. The show ran for three-and-a-half hours, and included songs from all ten of her eras. It was accompanied by a movie of the same name, which became the highest-grossing concert or performance film of all time.

Swiftie Snapshot

YEARS
2022–2024

ALBUM SPOTLIGHT
Midnights

GENRE
Synth-pop

HIT SONGS
"Anti-Hero"
"Lavender Haze"
"Bejeweled"
"Karma"

AWARDS
MTV Video Music Awards: Album of the Year for *Midnights* (2023)
Grammy Awards: Best Pop Vocal Album and Album of the Year for *Midnights* (2024)

FUN FACT

At the 2024 Grammy Awards, Taylor set a new record—when she won Album of the Year for *Midnights*, she became the performer with the most Album of the Year wins—four in total!

Taylor's Lucky Number

Her birthday is on December 13th.

Her first album went gold in 13 weeks.

Taylor announced her eleventh album, *The Tortured Poets Department*, onstage when she won her 13th Grammy.

She turned 13 on Friday the 13th.

"Our Song," Taylor's first number-one song on the *Billboard* Country Chart, has a 13-second intro.

Folklore was released on July 24th (7/24). 7 + 2 + 4 = 13.

"The Lucky One" is the 13th track on *Red*, and has a 13-second intro. The word "lucky" is also sung 13 times!

Fearless (Taylor's Version) was released on April 9 (4/9). 4 + 9 = 13.

In the music video for "Ours," her cubicle is on the 13th floor.

"Mastermind," the 13th song on *Midnights*, peaked at #13 on the *Billboard* Hot 100.

In "Cardigan," she sings "I knew you" 13 times.

In "Willow," she sings "That's my man" 13 times.

Lover was released on August 23rd (8/23). 8 + 2 + 3 = 13.

V Festival

Movie Premier

"Long Live"

Westfield London

VMA Red Carpet

Pop Artist

Tour of the Year

Woman of the Decade

Eras Tour